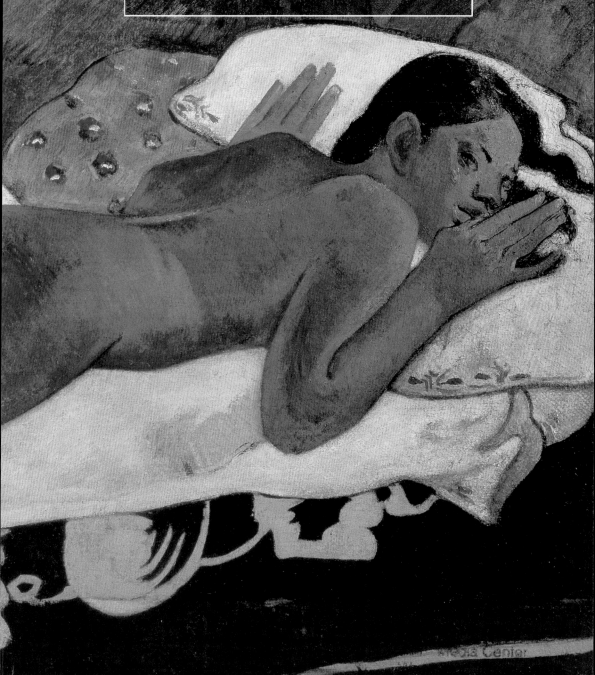

GAUGUIN
ESCAPE TO EDEN

BY
DAVID SPENCE

Paul Gauguin and Mette Sofie Gad settled quickly into family life after they were married in 1873. The first of their five children was born in 1874 and they moved to a large house in the Parisian suburbs. Until this time there is no record of Gauguin's interest in art. It may have been Gustave Arosa who first stimulated Gauguin's interest; he owned a private collection of some importance with paintings by Delacroix, Courbet, and Corot as well as more "modern" pictures by the Impressionist Pissarro. Gauguin started buying paintings himself, concentrating on the new style with artists such as Monet, Renoir, Degas, and Cézanne. He also started painting, attending a few art classes, and setting up a studio in his house. In 1876 Gauguin's painting of *Undergrowth at Viroflay* was accepted for exhibition at the Paris Salon. He took a less taxing job in order to have more time to paint. In 1883, after the financial disasters of the stock market crash, Gauguin quit his job to become a full-time painter.

BRETON GIRLS DANCING, 1888

Gauguin's wife, Mette, gave up hope of her husband supporting her and their five children as an artist. She returned to Denmark supporting herself and the children by working as a French teacher.

In 1885 the family were reunited as Gauguin tried a fresh start in Rouen. His paintings did not sell, however, and Mette eventually took the children back to Copenhagen with the exception of their third child, Clovis, who stayed with Paul. In 1886 he moved to Brittany, a popular (and inexpensive) summer retreat for artists. Gauguin was to find the Brittany landscape and its inhabitants a rich source of imagery for his painting to which he would return again and again.

THE WORLD OF GAUGUIN

PHOTO OF LIMA IN
THE 19TH CENTURY

Eugéne Henri Paul Gauguin was born in Paris on June 7, 1848. His father, Clovis Gauguin, was editor of the liberal newspaper *National*. His mother, Aline Marie Chazal, was just 22 years old when Paul was born and already had one daughter, Marie. Aline's mother was part Spanish; her ancestors were among the first Spanish settlers in Peru, and the relatives who stayed there were powerful and wealthy. Gauguin's parents were encouraged to start a new life in Peru after Louis Napoleon Bonaparte was elected president of the French Republic in 1848. The newspaper *National,* under Clovis Gauguin's editorship, had been critical of Napoleon and Clovis decided there was no future for the Gauguin family in France. So Paul Gauguin's early years were spent in Peru. When he was six years old he returned to France, and attended boarding school in Orléans. His unhappy school days were filled with memories of happier times in Peru and as soon as he was old enough to leave he joined the merchant navy, embarking as officer-in-training on a ship bound for South America. Gauguin was to spend his whole life seeking the lost paradise of his childhood.

Clovis and Aline Gauguin with their children Paul and Marie set sail for South America on August 8, 1849. Tragedy struck early when Clovis died of a heart attack en route, and was buried in Patagonia. Aline arrived with her two children at Lima to be met by her great-uncle, who held considerable political power and wealth. Consequently the Gauguins entered a paradise world with servants attending to their needs and no fear for their financial security. Their home was described as *"A vast and luxurious residence where grand receptions were given and the most eminent figures of the Peruvian government mingled."* However a civil war forced the Gauguins to return to France in 1855.

AN OFFICER IN TRAINING

When Gauguin was 16 he entered the merchant navy, joining the ship *Luzitano* as officer-in-training, bound for Rio de Janeiro. While on an Atlantic crossing in 1867 his mother died. Aline had named a Parisian friend, Gustave Arosa, as legal guardian of the Gauguin children. After Paul had served his time in the French Navy on board the *Jérôme-Napoléon* (similar to the ship shown right) he returned to Paris in 1871 to live with his sister in the Rue la Bruyere, near the Arosa family. Gustave Arosa arranged for Gauguin to take up a job as a stockbroker in the Paris stock exchange. Not long afterward he met a young Danish governess named Mette Gad whom he married in 1873.

INFLUENCES & EARLY WORKS

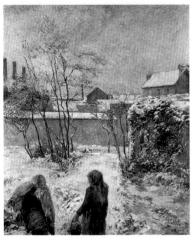

EFFECTS OF SNOW ON THE RUE CARCEL

This painting, completed in 1883, shows Gauguin's work when he was under the influence of Pissarro and the Impressionist group. Pissarro himself did a number of paintings evoking winter scenes; Gauguin's painting of the fleeting effects of snow on the landscape are in line with the Impressionist's desire to capture the transitory nature of the landscape.

G auguin had no real formal training as an artist and did not take up painting until he was about 25 years old. His wife, Mette, said she did not know Paul had any interest in painting when they first met. His legal guardian, Gustave Arosa, was an undoubted influence serving to open Gauguin's eyes to art. Camille Pissarro became an important early influence, encouraging Gauguin as he did other promising artists such as Vincent van Gogh. In 1879, at Pissarro's invitation, Gauguin exhibited with the Impressionists' fourth exhibition. By the early 1880s Gauguin was exhibiting regularly with the Impressionists and became a collector of works by other Impressionist artists. Gauguin's new artistic friends included the Impressionist painters but also the café society intellectuals. Writers such as Stéphane Mallarmé and Arthur Rimbaud, the leading Symbolist poets, encouraged artists such as Odilon Redon and Paul Gauguin to join the Symbolist movement.

PORTRAIT OF PISSARRO AND GAUGUIN (*left*)

Camille Pissarro, some years older than Gauguin, became Gauguin's friend and artistic mentor. Pissarro was extremely influential, encouraging Gauguin to adopt the Impressionist techniques and to seek out the type of subject matter that the Impressionist artists depicted. The development of Gauguin's work toward Symbolism caused Pissarro to criticize him, saying of his highly Symbolist representations of Breton women and other canvases, *"I reproach him for pinching this (style) from Japanese and Byzantine and other painters. I reproach him for not applying his synthesis to our modern, completely social anti-authoritarian and antimystical philosophy. . . . This is a step backward."*

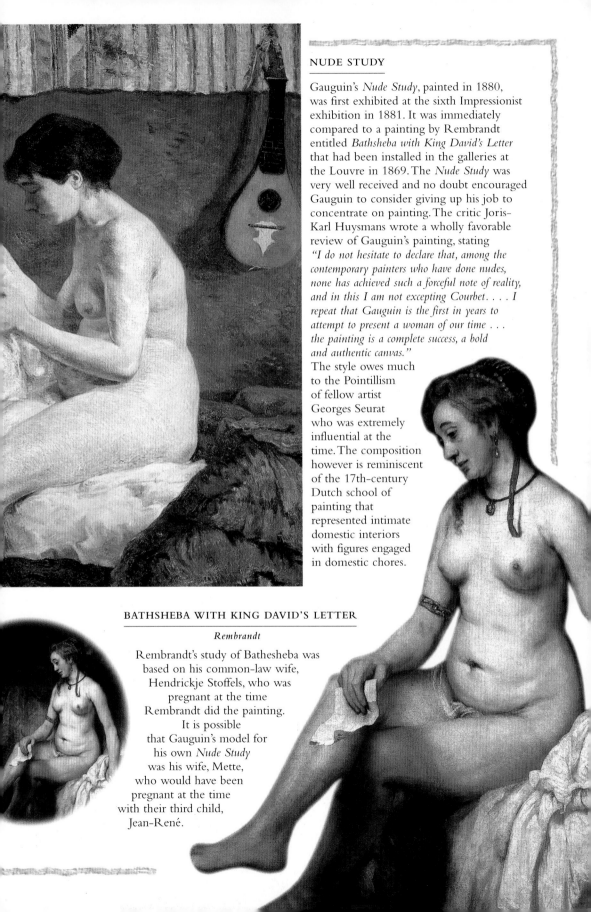

NUDE STUDY

Gauguin's *Nude Study*, painted in 1880, was first exhibited at the sixth Impressionist exhibition in 1881. It was immediately compared to a painting by Rembrandt entitled *Bathsheba with King David's Letter* that had been installed in the galleries at the Louvre in 1869. The *Nude Study* was very well received and no doubt encouraged Gauguin to consider giving up his job to concentrate on painting. The critic Joris-Karl Huysmans wrote a wholly favorable review of Gauguin's painting, stating *"I do not hesitate to declare that, among the contemporary painters who have done nudes, none has achieved such a forceful note of reality, and in this I am not excepting Courbet. . . . I repeat that Gauguin is the first in years to attempt to present a woman of our time . . . the painting is a complete success, a bold and authentic canvas."* The style owes much to the Pointillism of fellow artist Georges Seurat who was extremely influential at the time. The composition however is reminiscent of the 17th-century Dutch school of painting that represented intimate domestic interiors with figures engaged in domestic chores.

BATHSHEBA WITH KING DAVID'S LETTER

Rembrandt

Rembrandt's study of Bathesheba was based on his common-law wife, Hendrickje Stoffels, who was pregnant at the time Rembrandt did the painting. It is possible that Gauguin's model for his own *Nude Study* was his wife, Mette, who would have been pregnant at the time with their third child, Jean-René.

THE ART OF HIS DAY

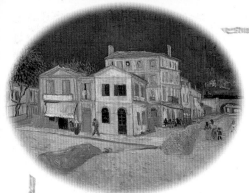

THE YELLOW HOUSE AT ARLES

Vincent van Gogh

Another artist struggling to make his way at the same time as Gauguin was the Dutch-born painter Vincent van Gogh. The tragic story of this artist's life and death at his own hands is well known. Van Gogh was looking for a way of expressing himself through color. Many of his concerns about representing feelings through color and line were shared by Gauguin. The two lived together for a short period in 1888 when Gauguin went to stay with the lonely van Gogh at his little yellow house in Arles. The two quarreled and to van Gogh's dismay Gauguin left. Thrown into despair by his departure van Gogh severed his own ear.

The conventions of 19th-century art were changed forever by the "Realists" such as Courbet and Manet who painted life as it truly was, with the peasants and prostitutes who inhabited the real world rather than idealized subjects or classical stories. "Realism" gave way to the Impressionists who carried this notion even further, taking their paints and canvases outdoors, *en plein-air*, in their attempt to capture the immediacy and spontaneity of life. Although Gauguin was heavily influenced by, and exhibited with, the Impressionists, he started searching for a new style. By the mid-1880s when Gauguin was trying to find his own way of painting, artists were completely freed from the belief that there was a "right way" to depict nature. It was suddenly understood that no objective view could exist; the passing of time, the changing light, and the way in which the artist observed, all influenced the depiction of the subject. During the 1880s and 1890s artists sought new ways of representing the world.

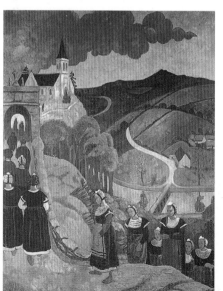

NOTRE DAMES DES PORTES

Paul Serusier

Paul Gauguin developed a style of painting that was notable for the harsh black outlines around the subjects depicted and with flat areas of color within the lines, rather like stained glass. The style became known as Cloisonnism after the French word *cloison*, meaning "partition." He developed this way of painting while living in Pont-Aven in Brittany. Gauguin admitted a strong Japanese influence in his work, which appeared increasingly graphic and abstract in nature. He led a small group of artists, known as the Pont-Aven School, who lived in the little village and were inspired by Gauguin. This included Paul Serusier as well as Charles Laval and Émile Bernard.

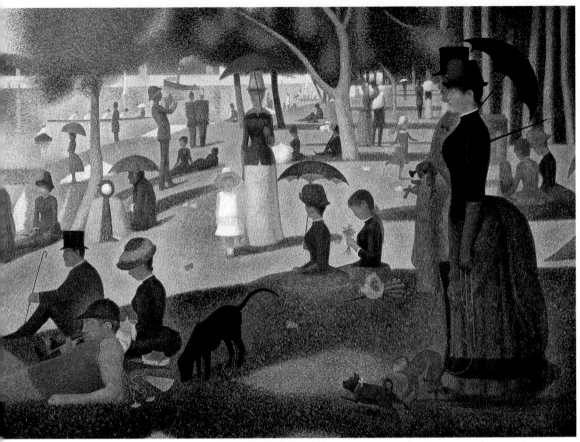

LA GRANDE JATTE

Georges Seurat

In 1886 Seurat's painting *La Grande Jatte* was shown at the eighth and last Impressionist exhibition in Paris. Seurat's painting was a sensation. The critics did not know what to make of this extraordinary painting executed in the "Pointillist" style, but it certainly was the center of attention. Seurat had for some time been working in a style that relied upon scientific principles relating to color theory. He painted with dots of color laid side-by-side that when viewed from a distance blended together, "mixing" the colors in the viewer's eye rather than on the canvas. Although the development of color photography and printing was in its infancy, Pointillism corresponded to the same scientific principles applied to the mechanical reproduction of images. Many artists experimented with this technique, including the Impressionist painter Pissarro and in turn Gauguin himself.

KITCHEN STILL LIFE *(detail) Paul Cézanne*

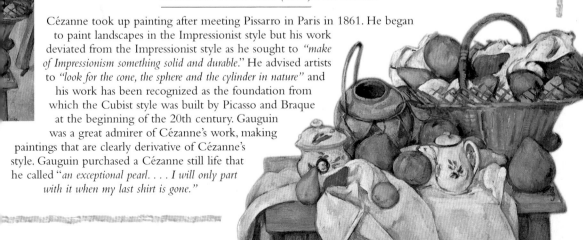

Cézanne took up painting after meeting Pissarro in Paris in 1861. He began to paint landscapes in the Impressionist style but his work deviated from the Impressionist style as he sought to *"make of Impressionism something solid and durable."* He advised artists to *"look for the cone, the sphere and the cylinder in nature"* and his work has been recognized as the foundation from which the Cubist style was built by Picasso and Braque at the beginning of the 20th century. Gauguin was a great admirer of Cézanne's work, making paintings that are clearly derivative of Cézanne's style. Gauguin purchased a Cézanne still life that he called *"an exceptional pearl. . . . I will only part with it when my last shirt is gone."*

THE LIFE OF GAUGUIN

~1848~

Paul Gauguin is born on June 7, as Eugéne Henri Paul Gauguin

~1849~

Gauguin and his family sail for Peru—Gauguin's father, Clovis, dies enroute

Gauguin lives in Lima with his mother Aline and his sister Marie

~1853~

Family return to Orléans, France

~1865~

Gauguin joins the merchant navy

~1867~

Gauguin's mother, Aline, dies while Gauguin is at sea

~1872~

Starts work as a stockbroker, paints as a hobby

~1873~

Marries Mette Gad

~1874~

Birth of their first child Emile

~1877~

Birth of his daughter Aline

~1879~

Exhibits at the Impressionist exhibition

~1881~

Exhibits at sixth Impressionist exhibition, dealer Durand-Ruel buys paintings

Birth of his son Jean-René

~1883~

Loses job as a stockbroker and concentrates on painting

Birth of his son Paul

YOUNG GIRL ASLEEP

Gauguin's favorite child was Aline, the couple's second, born on December 24, 1877. She had been named after Gauguin's mother. Gauguin carried a photograph of his daughter with him when he left the family to go and live in Tahiti. He doubtless felt terrible guilt and sorrow when in 1897 he received a letter from Mette informing him that Aline had died of pneumonia on January 19. Soon afterward Gauguin took a dose of arsenic in an attempt to kill himself, but recovered.

BUST OF METTE GAUGUIN *Jules-Ernest Bouillot*

Gauguin met Mette Gad in Paris, and they married in 1873, quickly settling into an uneventful routine in suburban Paris. Mette gave birth to the first of their five children in 1874. After Gauguin had devoted himself entirely to painting and steadily spent all their money, Mette had no alternative other than to return to her family in Denmark with the children.

They were never to be properly reunited again. Gauguin wrote to Mette; *"there are two natures in me, the Indian and the sensitive man. The sensitive man has now disappeared, letting the Indian go ahead strong and straight."* When after his travels to Brittany and Martinique Gauguin finally set sail for Tahiti, he said good-bye forever to his wife and children.

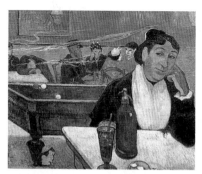

CAFÉ AT ARLES, 1888

Gauguin painted this picture when Vincent van Gogh's brother, Theo, arranged for Gauguin to go and stay with Vincent in Arles in 1888. It was because Gauguin relied on the art dealer Theo's financial support that he agreed rather than out of a desire to stay with Vincent. Theo was anxious to provide support and friendship for his brother and Vincent's spirits were lifted at the news of Gauguin's agreement. He decorated Gauguin's room with paintings of sunflowers and thought of starting an artist's colony in Arles.

FAMILY, FRIENDS, & OTHERS

Gauguin with his eldest children— Émile and Aline.

Gauguin's family background makes colorful reading. He undoubtedly had Spanish ancestors with Peruvian ties but his claim that he was descended from Inca kings appears farfetched. The most famous of his family was his maternal grandmother, Flora Tristan, who made a name for herself as a writer and militant feminist advocating trade unions in the 1840s. Flora was the illegitimate daughter of Don Moscoso, whose family owned a large estate in Peru. Flora's unfaithful husband was jailed for 29 years after attempting to kill his wife. Their daughter, Aline, met and married Clovis Gauguin whose political views earned him persecution from the state, and prompted the Gauguin family to move to Peru to seek the support of Don Moscoso.

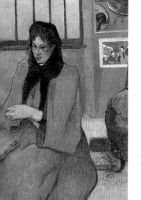

THE FAMILY SCHUFFENECKER, 1889

When Gauguin returned from his travels to Martinique he first went back to Brittany, then in 1889 to Paris where he stayed with Émile Schuffenecker and his family. Schuffenecker was a fellow painter with whom Gauguin had worked in his days as a stockbroker in the 1870s at Banque Bertin. His portrait of the family is not a complimentary one. Émile is unsympathetically depicted, almost caricaturelike, standing in the background looking toward his seated wife and children. Madame Schuffenecker, whom Gauguin had tried to seduce on earlier occasions leading to bad feeling between the two men, is shown with a clawlike hand. Despite Schuffenecker's help and financial support, the picture dismisses Émile's work as an artist by turning his canvas side-on so it is invisible to the viewer.

THE LIFE OF GAUGUIN

~1884~

Mette returns to
Denmark with their children

~1886~

Gauguin goes to Pont-Aven
in Brittany to paint

~1887~

Goes to Panama
and Martinique

~1888~

Stays with Vincent
van Gogh in Arles

~1889~

First exhibition in Paris
of the Impressionist
and Synthetist group

~1891~

Goes to Copenhagen to
say good-bye to his family
then leaves for Tahiti

~1893~

Returns to Paris

~1895~

Goes back to Tahiti
and builds himself a house

~1896~

Gauguin and Pahura have
a daughter who dies
shortly after birth

~1897~

Daughter Aline dies

~1897~

Gauguin attempts suicide

~1898~

Pahura gives birth
to son Émile

~1901~

Moves to the remote
Marquesas islands and builds a
house where his vahine,
Vaeoho, gives birth to
daughter Tahiatikaomata

~1903~

Gauguin dies on May 8th

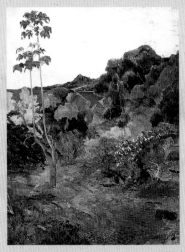

PAYSAGE DE MARTINIQUE, 1887

This view of the landscape of Saint Pierre bay deliberately depicts a tropical paradise untouched by an outside hand. In reality it was a developed town with European architecture (including a church with a steeple) and a busy port.

Gauguin's technique, breaking up the trees into blocks of color, is reminiscent of Cézanne's approach to landscape, which was so influential at the time. Nevertheless Gauguin is beginning to demonstrate a confident style of his own, and one notable art critic commented on Gauguin's Martinique paintings; *"he has finally conquered his own personality . . . he is his own master."*

Although Gauguin made no more than a dozen paintings in Martinique and returned after just a few months abroad, the experience was very important for him. He had discovered the tropical light and color that made his paintings come alive and had glimpsed into his "paradise world" that he sought to recapture.

A contemporary description of Martinique likens the island to *"one of the most precious pearls of France's colonial jewel box."* It should be remembered that the relationship between the artist and the place was one determined very much by France's dominion over its colonial outpost. Despite Gauguin's poverty his observations of the landscape and people reflected his own French (and Parisian) culture, which tended to idealize the exotic, "primitive" land and its inhabitants.

Gauguin's Western eye sought not only the secure, carefree existence of his early childhood but the supposed simplicity of an "undeveloped" society uncorrupted by Western values. When subsequently shown in Paris, Gauguin's paintings of Martinique were described as *"divine, Eden-like."*

WANDERLUST

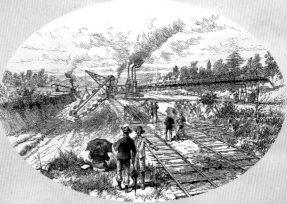

Gauguin's first attempt to recapture the happy and exotic memories of his lost youth in South America came in 1887, when he decided to journey to Panama with his fellow artist Charles Laval. Gauguin was desperate to bring about a change in his life and was hopelessly hard up, unable to bring in any money from his painting and described Paris *"as a wilderness for a poor man."* The idea was to seek the support of Gauguin's brother-in-law who lived in Panama. Mette visited Gauguin to collect their son, Clovis, who had been living with him, and returned to Denmark with Clovis and a number of Gauguin's paintings. Laval and Gauguin set sail on April 10, 1887 but stayed only a short time in Panama, moving on to the Caribbean island of Martinique.

CONSTRUCTION OF THE PANAMA CANAL

Gauguin's money ran out soon after arriving in Panama. His brother-in-law provided no help, and Gauguin got a job along with hundreds of others who had traveled to Panama to work for the Panama Canal Construction Company. In the 1880s a railway ran across the isthmus linking the Atlantic and Pacific Oceans, but ships had to sail thousands of miles around South America. The attempt to build a canal linking the two oceans failed when the company went bankrupt, and it was not until 1914 that the Panama Canal was finally opened.

SAINT PIERRE, MARTINIQUE

Work for the Panama Canal Construction Company did not last long. Gauguin was laid off after 15 days and the two friends went to Saint Pierre on the island of Martinique. Both Laval and Gauguin were seriously ill, having picked up malaria and dysentery, diseases that spread rapidly among the work force in the swampy conditions in Panama. Some years after Gauguin's visit, Saint Pierre was destroyed by a volcanic eruption that killed most of the town's population of 30,000. Today it is a thriving vacation destination.

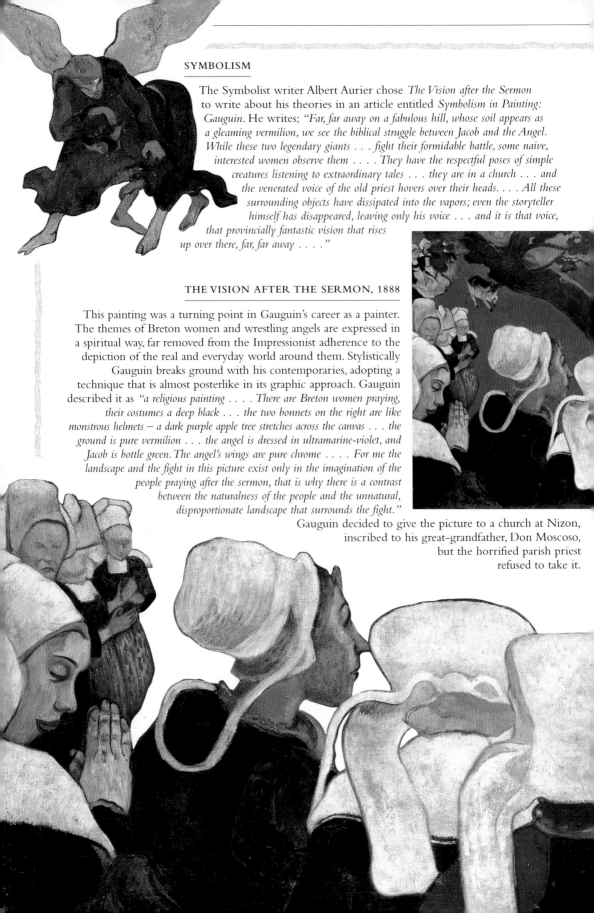

SYMBOLISM

The Symbolist writer Albert Aurier chose *The Vision after the Sermon* to write about his theories in an article entitled *Symbolism in Painting: Gauguin*. He writes; *"Far, far away on a fabulous hill, whose soil appears as a gleaming vermilion, we see the biblical struggle between Jacob and the Angel. While these two legendary giants . . . fight their formidable battle, some naive, interested women observe them They have the respectful poses of simple creatures listening to extraordinary tales . . . they are in a church . . . and the venerated voice of the old priest hovers over their heads. . . . All these surrounding objects have dissipated into the vapors; even the storyteller himself has disappeared, leaving only his voice . . . and it is that voice, that provincially fantastic vision that rises up over there, far, far away"*

THE VISION AFTER THE SERMON, 1888

This painting was a turning point in Gauguin's career as a painter. The themes of Breton women and wrestling angels are expressed in a spiritual way, far removed from the Impressionist adherence to the depiction of the real and everyday world around them. Stylistically Gauguin breaks ground with his contemporaries, adopting a technique that is almost posterlike in its graphic approach. Gauguin described it as *"a religious painting There are Breton women praying, their costumes a deep black . . . the two bonnets on the right are like monstrous helmets — a dark purple apple tree stretches across the canvas . . . the ground is pure vermilion . . . the angel is dressed in ultramarine-violet, and Jacob is bottle green. The angel's wings are pure chrome For me the landscape and the fight in this picture exist only in the imagination of the people praying after the sermon, that is why there is a contrast between the naturalness of the people and the unnatural, disproportionate landscape that surrounds the fight."*

Gauguin decided to give the picture to a church at Nizon, inscribed to his great-grandfather, Don Moscoso, but the horrified parish priest refused to take it.

FAMOUS IMAGES

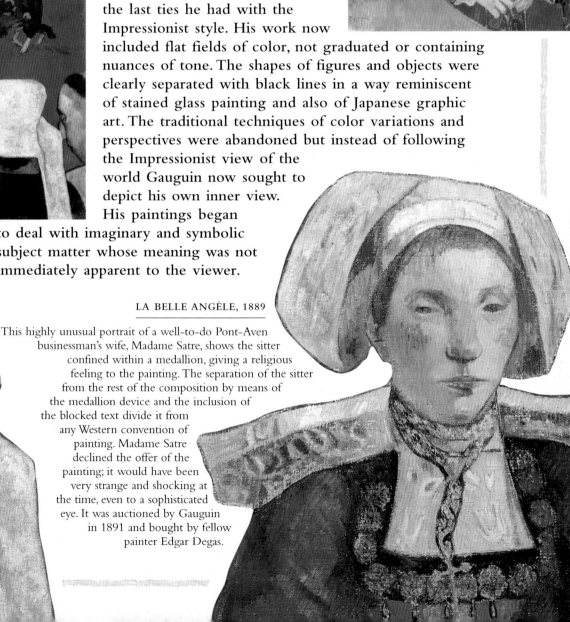

Gauguin returned to Brittany in 1888 but his thoughts were never far from Martinique. He experimented with new ways of painting, creating compositions that represented a new way of seeing things. The experience of painting in the tropics influenced his Breton paintings, which broke the last ties he had with the Impressionist style. His work now included flat fields of color, not graduated or containing nuances of tone. The shapes of figures and objects were clearly separated with black lines in a way reminiscent of stained glass painting and also of Japanese graphic art. The traditional techniques of color variations and perspectives were abandoned but instead of following the Impressionist view of the world Gauguin now sought to depict his own inner view.

His paintings began to deal with imaginary and symbolic subject matter whose meaning was not immediately apparent to the viewer.

LA BELLE ANGÈLE, 1889

This highly unusual portrait of a well-to-do Pont-Aven businessman's wife, Madame Satre, shows the sitter confined within a medallion, giving a religious feeling to the painting. The separation of the sitter from the rest of the composition by means of the medallion device and the inclusion of the blocked text divide it from any Western convention of painting. Madame Satre declined the offer of the painting; it would have been very strange and shocking at the time, even to a sophisticated eye. It was auctioned by Gauguin in 1891 and bought by fellow painter Edgar Degas.

THE ARTIST'S VISION
THE MARTYR

1889 was the year of the Universal Exhibition at the Palais des Beaux-Arts in Paris, celebrating the centenary of the French Revolution. It included an "official" art exhibition that refused to include avant-garde artists such as the Impressionists. An independent exhibition was organized by Emile Schuffenecker at the Café des Arts to show works by "refused" artists immediately next to the official exhibition area. The title of the independent exhibition was *Impressionniste et Synthétiste,* which clearly signaled the difference between the paintings of the Impressionists and the Synthetists such as Gauguin, Émile Bernard, and Charles Laval. The show did not make money but did create a stir among the contemporary art scene. The Synthetist painters intended to express their ideas and emotions through the use of brilliant colors that could also be used decoratively. They rejected any naturalistic representation of their subject in favor of creating a pictorial "synthesis"; an essence of the idea that inspired the picture. However the Universal Exhibition with its exhibits from distant parts of the French colonial empire spurred Gauguin to think again about leaving for the tropics once more.

STILL LIFE WITH JAPANESE PRINT, 1889

The independent exhibition attracted criticism and scorn from many, which stung Gauguin; he decided to return to Brittany. However Albert Aurier wrote; *"A small section is lacking in the Palais des Beaux-Arts for the few independent artists who, unknown to or scorned by the public . . . are working far from the official schools and academies, researching and developing a new kind of art, that will, perhaps, be the art of tomorrow."*

CHRIST IN THE GARDEN OF OLIVES, 1889

Gauguin was discouraged by the criticism of his work and felt alone. In this self-portrait as Christ in the garden of olives he places himself clearly in the role of the forsaken Christ awaiting betrayal. This identification demonstrates how much he felt the rejection of his art, how apparently hopeless was the quest for success and that his martyrdom was inevitable. He explained the picture by stating: *"It represents the crushing of an ideal, and a pain that is both divine and human. Jesus is totally abandoned, his disciples are leaving him . . ."* Gauguin was soon to decide that he should cut himself off from friends and critics alike: *"I am leaving for Tahiti, and I hope to stay there for the rest of my days. I think that my work . . . is but a seed that I can cultivate there in that wild and primitive place. For that I must have peace. What does it matter that the glory will belong to others?"*

SELF-PORTRAIT IN FRONT OF THE YELLOW CHRIST, 1889

Gauguin's paintings made while he was in Brittany included many representations of religious subjects. His imagery, depicted in a primitive style, showed the devout Breton peasants, the suffering Christ, and the Pietà. Although Gauguin was not particularly religious, he sympathized with the devotion of the Breton people and sought to capture their sense of passion and emotion. He portrayed himself in front of one of his own paintings, the *Yellow Christ*, thereby immediately identifying with the figure of Christ. His model for the crucifixion was a statue in the chapel of Tremalo, near the town of Pont-Aven. The expression on Gauguin's face is grave, the gaze serious and intent, full of resolve to carry out his mission as a painter.

15

AREAREA, 1892

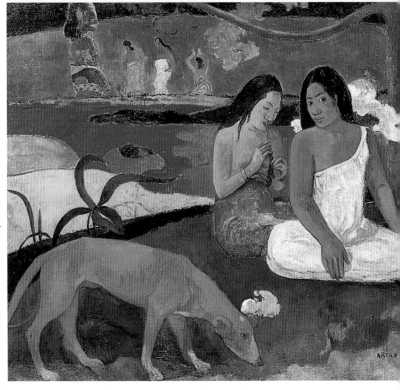

The title of this painting has been translated as "amusement" or "happiness" depending upon which interpretation of the Tahitian word is taken. The scene is possibly set in the evening; two seated female figures sit under a tree, while three others stand in the distance next to a statue of the Tahitian goddess Hina, goddess of the moon. One of the women plays a flute while the other, dressed in a white robe, stares boldly at the viewer. The foreground is dominated by an orange dog whose color and presence in the picture holds a symbolic meaning, possibly that of evil, as suggested by some critics. This is one of Gauguin's most successful Tahitian pictures, painted after he had been on the island for a year. Its carefully controlled use of color and composition create a harmonious effect, while the dog and staring woman maintain a sense of mystery, even menace.

WOMAN WITH A FLOWER, 1891

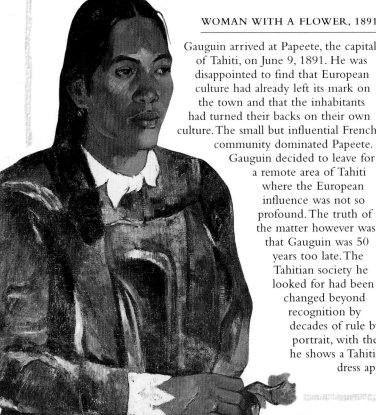

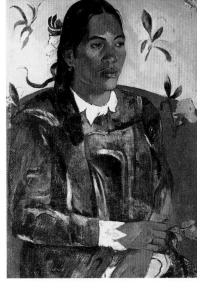

Gauguin arrived at Papeete, the capital of Tahiti, on June 9, 1891. He was disappointed to find that European culture had already left its mark on the town and that the inhabitants had turned their backs on their own culture. The small but influential French community dominated Papeete. Gauguin decided to leave for a remote area of Tahiti where the European influence was not so profound. The truth of the matter however was that Gauguin was 50 years too late. The Tahitian society he looked for had been changed beyond recognition by decades of rule by white European colonialists. In this portrait, with the Tahitian name of *Vahine Note Tiare*, he shows a Tahitian woman wearing a European-style dress approved by the missionaries.

ESCAPE

By 1889 Gauguin had decided to leave France for the tropics in the hope of finding a simpler, cheaper place to live and work, unsatisfied with the Brittany villages crowded with artists and from where he could still *"hear the jeers of Paris."* He was not discouraged by his earlier trip to Martinique and still believed he could find the exotic, happy, and secure place of his early childhood. In April 1889 he wrote; *"I have decided to leave for Madagascar Madame Redon says that with 5,000 francs you can live there for 30 years if you want to."* However he began to receive conflicting advice about the cost of living in Madagascar and in other destinations under consideration such as Tonkin (now known as Vietnam). Eventually Gauguin decided on Tahiti because Madagascar was *"too near the civilized world."* Gauguin auctioned 30 of his paintings to raise money for the voyage and all but one were sold. The total sales made 7,350 francs. He traveled to Copenhagen to say farewell to his wife and family after which he headed for Marseilles. On April 1, 1891 he embarked upon the ship *Océanien,* heading for Tahiti.

VIRGIN WITH CHILD, 1891

The Tahitian title *Ia Orana Maria,* inscribed in the box at the bottom of the painting, translates as "We greet thee, Mary," the Angel Gabriel's words to the Virgin Mary. In the foreground stands the figure of Mary, a Tahitian woman with a child upon her shoulders. Both woman and child have haloes encircling their heads. The Angel Gabriel can be seen in the background on the left, partially obscured by trees. Gauguin's painting of a Christian subject is depicted in a style that borrows heavily from traditional European painting. The costumes and exotic fruits in the foreground, however, remove the painting from this European context, and the two female figures facing Mary stand in the Buddhist prayer pose. The painting can be seen to be not only Gauguin's symbolic interpretation of the subject but also a representation of the conflicting religious influences prevalent at the time.

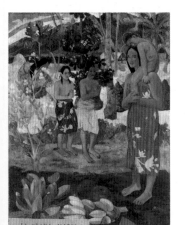

IA ORANA MARIA

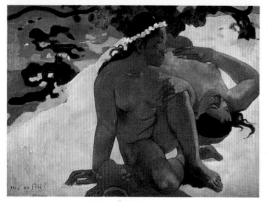

WHAT, ARE YOU JEALOUS? 1892

The composition of this painting entitled *Aha oe feii* is similar to *Nafea faa ipoipo* and *Women on the Beach,* but what is striking about this painting is the boldness with which the naked women are portrayed. No longer are his subjects dressed in the modest missionary-approved long dresses or even the local colorful wraps. The content together with the title carries a clear sexual connotation. The seated figure appears to be posing the question to the viewer rather than to the figure lying on the beach, an impression reinforced by the woman's sideways glance at the viewer.

WHAT DO THE PAINTINGS SAY?

Gauguin was disappointed with his surroundings in Papeete, the Tahitian capital. It was a busy town with as many Europeans and Chinese merchants as Tahitians. Gauguin was anxious to paint subjects that represented the traditional Tahitian way of life, its customs, culture, and religion. He found little opportunity to do so in Papeete, so he moved to Mataeia, which was some 50 kilometers distant, but the real Tahitian world continued to elude him. Not only had European culture changed forever the way in which the indigenous population lived, but Gauguin deluded himself when he thought that he had found a corner of the world untouched by Western hand. He was so keen on re-creating the tropical paradise of his childhood that he pretended his paintings were giving a firsthand insight into a disappearing culture. In fact Gauguin's images were heavily influenced by a book of Tahitian customs that had been given to him by a colonist living in Tahiti. Nevertheless Gauguin's pictures became the true image of Tahitian life in the eyes of the Western world and remain so today, reinforced by Hollywood film clichés depicting unspoiled Tahitian islands, beautiful women, and food that falls from the trees.

WOMEN OF ALGIERS

Eugéne Delacroix

Gauguin took many prints with him to Tahiti. He referred freely to these reproductions of paintings by well-known artists and in many cases used the motifs in his own work. This detail from Delacroix's *Women of Algiers* compares to the seated figures in several of Gauguin's Tahitian paintings. Gauguin deliberately transposed Western subjects, painting them in a Tahitian setting, attempting to place his own work in the context of the European art that he admired.

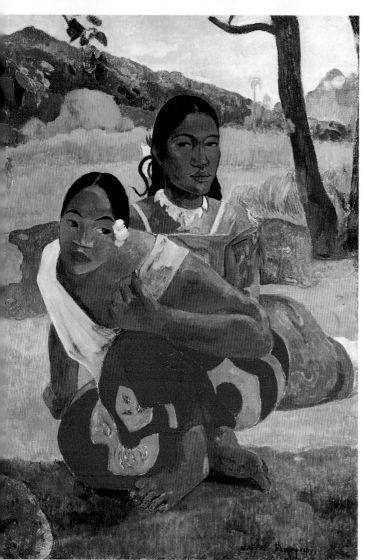

WHEN WILL YOU MARRY? 1892 (NAFEA FAA IPOIPO)

The question in the title of this painting is probably being posed by the women in the background to the woman whose wish to find a husband is expressed according to Tahitian ritual – a flower worn behind her ear. Gauguin priced this picture at 1,500 francs when it finally went on exhibition in Paris, higher than any other canvas. Gauguin's work appealed to a Parisian audience fascinated by the exoticism of faraway Pacific islands. The subject may even have been deliberately chosen to illustrate a subject with which a French audience would have been familiar because of the popularity of the book *Le Mariage de Loti*, written by Julien Viaud in 1880. This book, which portrayed Tahiti as an exotic paradise, captured the imagination of its European readers. Viaud had visited Tahiti as a young naval officer and had a relationship with a Tahitian woman. He was given the Tahitian name Loti, the name of a flower.

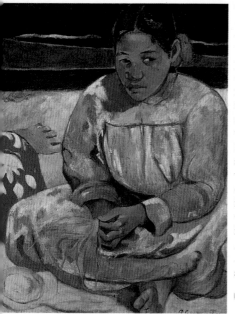

TWO TAHITIAN WOMEN ON THE BEACH, 1891

This picture of two women portrays the activity of collecting the vegetal fibers that were to be found on the beach and that the Tahitian women used for weaving. Strands of the fiber can be seen in the hands of the woman wearing the pink dress. The fibers are coiled into a stylized pattern. Gauguin painted an almost identical picture entitled *Parau Api – Women on the Beach*, which translates as *What News?*

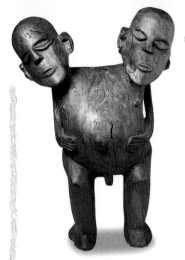

WHAT DO THE PAINTINGS SAY?

TAHITIAN WOODEN FIGURE

Gauguin made many references to Tahitian idols, both in his paintings and sculptures. These were often imaginary figures based partly on Tahitian idols but also freely adapted from Easter Island statues and other stone sculptures found in the area. His re-creation of *Oviri moe-ahere*, the goddess of death, appears in paintings and sculptures and had a special significance for Gauguin, who asked for a version to be on his gravestone. His wish was finally granted in 1973.

These words, written in Gauguin's notebook, echoed those of Delacroix; *". . . there is an impression that results from a certain arrangement of colors, of light, of shadows. One might call it the music of painting. Even before you know anything about a painting, you enter a cathedral and you find yourself too far from the picture to know what it represents, yet often you are struck by this magical harmony. Herein lies painting's true superiority over other arts, for this emotion addresses the most intimate part of the soul."* Gauguin was never far from Western traditions in the stylistic execution of his subject matter, as this reference to Delacroix demonstrates, and even his subjects reflect the overlaying of Western cultural influences over indigenous Tahitian culture. This is most evident in the continuing religious references in the paintings where imagery sits alongside Polynesian imagery. In fact the years of colonial rule had eroded much of the local way of life, and Gauguin sought to resurrect local customs in his paintings that had long since been forgotten.

OLYMPIA (*detail*)
by Édouard Manet

THE SPIRIT & THE GHOST

The painting, *Spirit of the Dead Watching*, shows the young girl *Teha'amana* lying on her bed, in fear of the tupapaus – "the spirits of the dead." The Tahitians believed that sleeping in the dark made them vulnerable to these spirits, which often appeared in the form of phosphorecences. Gauguin shows the spirits as flowers in the background. He describes painting them *"like sparks of light,"* and goes on to say *"I made the ghost quite simply like a little old lady; because the girl, not knowing French theatrical images of spirits, can only imagine . . . a human being like herself."*

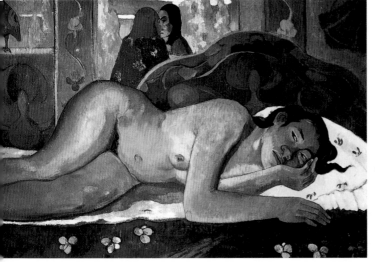

NEVERMORE, 1897

Gauguin described this painting in a letter to a friend; *"With a simple nude I wished to suggest a certain long-gone barbaric luxury. It is all drowned in colors which are deliberately somber . . . its title,* Nevermore, *not exactly the raven from Edgar Poe, but the bird of the devil which keeps watch."* Again there is a reference to Manet, both through Olympia and his illustrations of Edgar Allen Poe's poem *The Raven*.

SPIRIT OF THE DEAD WATCHING, 1892 (MANAO TUPAPAU)

This powerful painting (below) demonstrates the varying influences that make up Gauguin's painting. There is a clear reference to Édouard Manet's painting *Olympia*, which had caused a storm when first exhibited in Paris in 1865, and that had itself looked back to earlier paintings by Titian and Goya. Gauguin had made a copy of Manet's painting and knew it well. *Manao Tupapau* also contained references to Tahitian folklore appreciated by Gauguin not at firsthand, as he would like his audience to think, but from J. A. Moerenhout's book *Voyages aux Îles de Grand Océan*, first published in 1837 and read by Gauguin in 1892. This influential book charted the customs and rituals of Polynesia before they had been eroded by European colonialism.

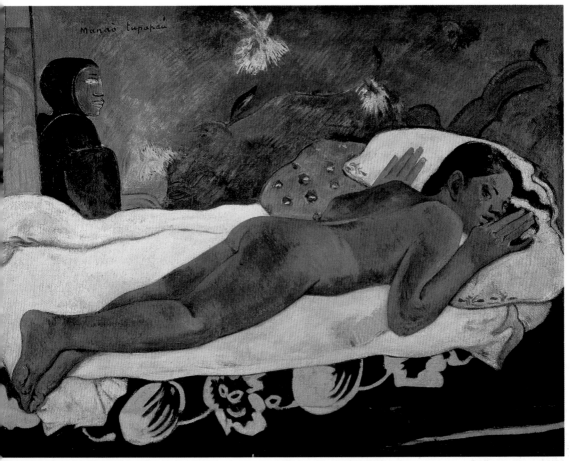

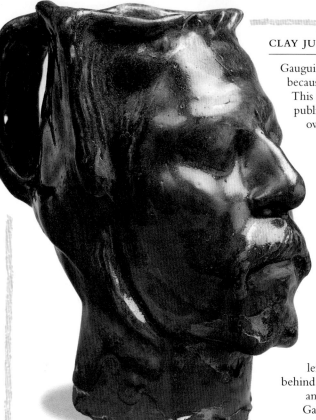

CLAY JUG IN THE FORM OF A SEVERED HEAD

Gauguin made several clay pots known as "stoneware" because of the type of clay used and how it was fired. This one was made in response to witnessing a public execution in Paris but shows Gauguin's own features. The gory red glazed finish appears as dripping blood.

MANAO TUPAPAU

Gauguin made a number of prints from woodcuts. The surface of a panel of wood was carved to produce an image "in reverse." The parts of the surface left untouched were rolled with ink or paint so that when pressed onto paper these parts left a "positive" image

behind. The parts of the wood carved away did not carry any ink so they appeared as light areas on the paper. Gauguin then colored many of these woodcut prints with watercolor so each print was different.

BE MYSTERIOUS

Gauguin carved this lime wood panel in 1890. It is a companion piece to a panel carved a year earlier entitled *Be in Love and You Will Be Happy*. Gauguin was very pleased with his carved panel and valued it at three times the price of his paintings. The imagery looks very exotic but it was made before he traveled to Tahiti. The modeling to the back of the central figure is very accomplished and it may be that Gauguin first practiced wood carving while on his long sea voyages both as a sailor and as a passenger. Carving in wood and in other materials was a common craft among sailors who often had long periods of time to spare, and invariably both a knife and pieces of wood at hand.

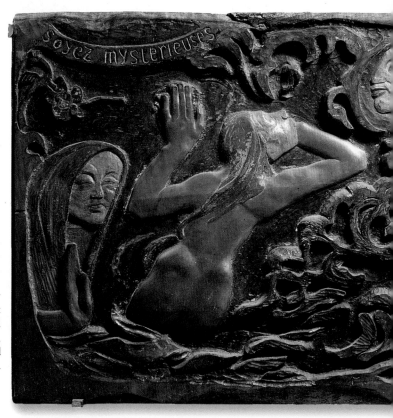

HOW WERE THEY MADE?

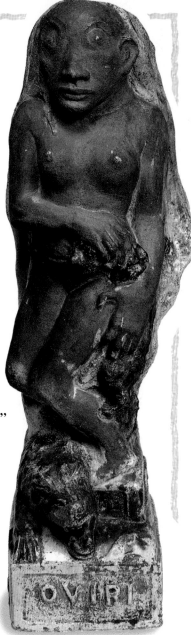

Gauguin experimented with many different types of materials and ways of creating images. He had no real formal training although he had help from the likes of Pissarro early in his painting career. He was happy to experiment with wood carving and clay modeling as well as oil painting, and developed a great love of wood carving when in Tahiti. He occasionally tried his hand at watercolors and less conventional means of producing pictures, such as woodcut prints. In order to explain his experiences in Tahiti he decided to write a book that carried the title *Noa Noa*, which might be translated as "rich in fragrances." The book, written in Gauguin's own hand complete with corrections, was highly illustrated. He made a series of woodcuts in a deliberately "primitive" style with decorative borders and hand painted in watercolor. These woodcut prints were for *Noa Noa* but also were to be sold as printed images. Gauguin had problems obtaining paint supplies when he was in Tahiti. To add to his problems he found that the climate made the paint dry very quickly so he had to adjust his way of painting accordingly. He ordered Lefranc's decorators' colors from France because they were inexpensive.

OVIRI MOE-AHERE

This highly unusual sculpture of *Oviri moe-ahere*, the "savage" goddess of death who is also known as the murderess *La Tueuse,* is modeled in clay. The figure holds a wolf cub while a dead wolf lies under her feet. Gauguin made the figure on his return to Paris from Tahiti in 1894. It was made at Ernest Chaplet's studio from clay, modeled like a vase, creating a hollow center. Gauguin submitted the sculpture to the Beaux-Arts Salon, which refused it. An indignant Gauguin wrote to the newspaper *Le Soir; "I had seen the possibility of giving a new thrust to ceramic art by creating new, handmade forms . . . to replace the (potter's) wheel with intelligent hands that could communicate to the vase the life of a figure while remaining faithful to the character of the material . . . this was my aim."* After his death a bronze cast of the figure was eventually made and stood at Gauguin's grave, as he had wished.

PHOTO OF TOHOTAUA

Tohotaua was an exceptionally beautiful young Marquesan who was a model for several paintings including *Young Girl with a Fan* (see page 25) and *Contes Barbares* (see page 28). Tohotaua is thought by some to be the wife of Haapuani, the sorcerer, and it is not known whether she ever shared Gauguin's bed. The photograph however was taken in Gauguin's house and in the background it is possible to see reproductions hanging on the wall. The painting of *Mrs. Holbein and Her Children* can be identified, as can *Dancers and Harlequin* by Edgar Degas and *Hope* by Pierre Puvis de Chavannes. This is clear evidence of the continued interest Gauguin demonstrated in the artistic works of others, and it is known that he carried with him to Tahiti many reproductions of paintings. The fact that Gauguin copied some of his compositions directly from those reproductions shows that he not only maintained an interest in traditional European art but did not fear showing that interest.

ANNAH THE JAVANESE

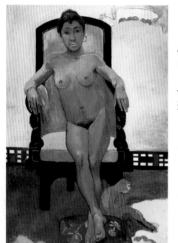

Gauguin painted this portrait of Annah, who was in fact part Sri Lankan (then Ceylon) and part Malay, in 1894 when he was in France. He had become infatuated with the 13-year-old girl much to the disgust of his family who were still in touch with Gauguin from their home in Denmark. To make matters worse he added a title in Tahitian that is just about visible on the top right of the picture. This reads *Aita tamari vahine Judith te parari* that can be translated as 'The child woman Judith is not yet breached." It does not refer to Annah at all but to another young acquaintance, the 12-year-old Judith Erikson-Molard.

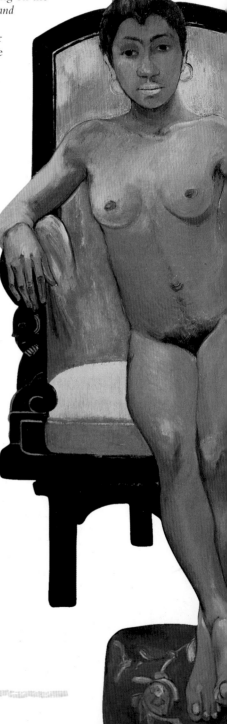

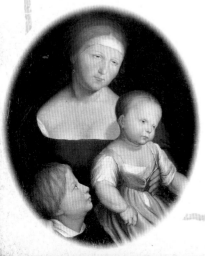

MRS. HOLBEIN & HER CHILDREN

Hans Holbein the Younger

This was one of the many paintings by different artists whose work was carried with Gauguin to Tahiti in reproduction form.

A VIEW OF WOMEN

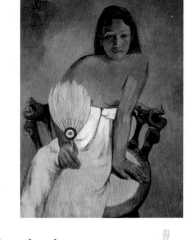

Gauguin was attracted to the way of life in Tahiti, which he saw as a "primitive splendor" without the material concerns of his native France. He had hoped to be able to live simply, to paint without the need to do any other work to earn his living, and to be free from the petty politics of critics and artists alike. However when he returned to Tahiti for the last time in 1895 he was lonely, plagued by ill health, and unable to change the fact that he, too, was an outsider in this society; another French colonial whose behavior was sometimes no better than any other. He displayed the worst traits of his character in his attitude to the young Tahitian women among whom he took several mistresses. He continued his interest even after he knew he was suffering from syphilis. Gauguin chose partners who were younger than would have been acceptable in European society. These mistresses were the models for a number of paintings, often as anonymous models but sometimes sitting for portraits under their own names. Gauguin's bohemian lifestyle was unacceptable at home and became problematic in Tahiti when he upset the local community.

YOUNG GIRL WITH FAN, 1902

Tohotaua was the model for this painting, which is clearly based on the photograph taken by Gauguin. The artist makes some key changes to the photograph, however, by making her gaze into space instead of engaging the viewer's eye directly, and by removing the *pareo* or "wrap" so that her breasts are revealed. Tohotaua holds a fan in front of her, partially covering her nakedness. This portrait is an image of a Polynesian woman that is entirely of Gauguin's making but that has now become a standard representation of the South Sea Island female.

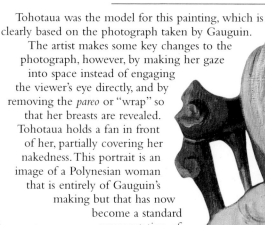

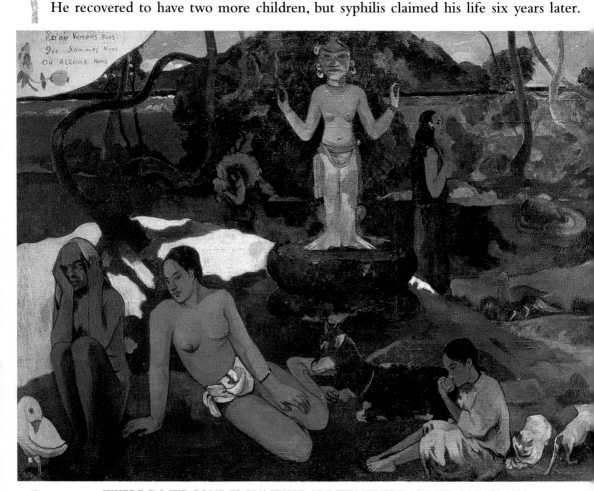

THE UNANSWERED QUESTIONS

**ALINE
GAUGUIN**
ca. 1895

G
auguin returned to Tahiti in 1895. He built a house in Punaania, just south of Papeete, where he lived with Pahura, his new mistress. Things quickly went wrong and his health and finances failed him. In 1896 a daughter was born to Gauguin and his *vahine* (mistress) but the baby died shortly after birth. In April 1897 he received a letter from his wife, Mette, informing him that their daughter Aline had died of pneumonia. Gauguin was plunged into deep depression by the news of Aline's death and finally attempted suicide by taking an overdose of arsenic. He recovered to have two more children, but syphilis claimed his life six years later.

WHERE DO WE COME FROM? WHAT ARE WE? WHERE ARE WE GOING? 1897

"I wanted, before dying, to paint a large picture that preoccupied me during that whole month; I worked day and night in an extraordinary fever." Gauguin painted a monumental work, the largest he ever painted, and called it *Where Do We Come From? What Are We? Where Are We Going?* It is regarded by many as his last important picture. After finishing his painting he walked to the top of a nearby hill and took a massive dose of

The old woman represents the end of life.

This is not a Tahitian goddess but represents a woman becoming an idol.

The scene is compared with the Garden of Eden. This figure appears to be taking a fruit from the tree of knowledge.

The strange white bird with the lizard in its claws represents the futility of vain words.

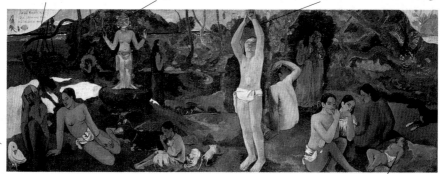

The painting is an inventory of the world, and includes people, animals, vegetation, rocks, water, and sky.

The child represents the beginning of life.

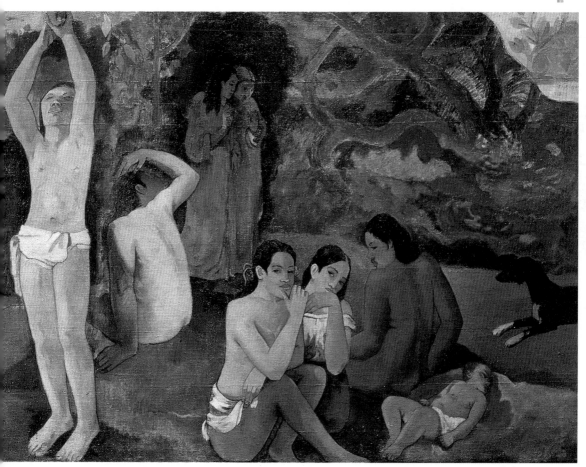

arsenic but he took so much that he simply made himself sick. He never managed to paint anything to equal this huge painting in the final six years of his life. The painting was made on a four-meter length of sackcloth material and was probably prepared from drawings made on squared-up tracing paper despite Gauguin's assertion that he made no preparations for the great work. Gauguin regarded *Where Do We Come From?* as a "philosophical work." He said it should be "read" from right to left: this way of reading is common with Eastern texts.

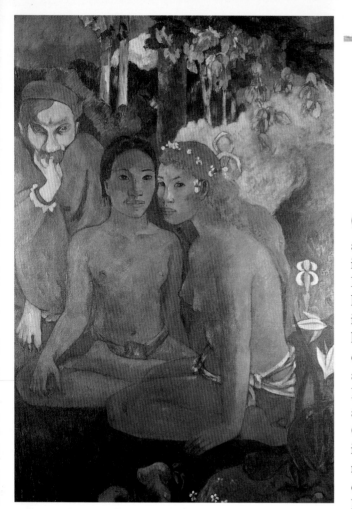

CONTES BARBARES, 1902

In this painting, the title of which can be translated as *Primitive Tales*, Gauguin presents three figures in a flower-filled landscape. It is difficult to tell whether the central figure is male or female but he or she sits in the lotus position. On the right is a kneeling red-haired woman. On the left an extraordinary figure whose features are reminiscent of Meyer de Haan, Gauguin's friend from Pont-Aven in France. This man-creature has clawed feet like an animal and feline eyes. The writer Bengt Danielsson suggests that the red-haired woman who also appears in earlier paintings by Gauguin is Tohotaua, wife of the sorcerer Haapuani. There is a coming together in this painting of Western thought, as represented by de Haan who was an occultist; Buddhism as represented by the central figure; and Maori folklore represented by the flame-haired wife of the Marquesan sorcerer. This combination would have appealed to the Symbolist Gauguin.

WHAT THE CRITICS SAY

*G*auguin has been portrayed over the years as a defender of the Tahitian people against the corruption and insensitivity of the colonial Europeans. Certainly Gauguin likes to give this impression in his own writings, such as in his book *Noa Noa* where he describes his quarrels with the authorities: the chief of justice of Papeete, the colonial authorities, and not least the Catholic Church. Gauguin's defense of the islanders however was as much to do with his own disagreement with these European powers as it was to do with sympathy for the local population. His attitudes, particularly those toward women, were sometimes as deplorable as any colonialist. While Gauguin struggled to paint in his poverty-stricken state in Polynesia his reputation as an artist began to grow in Europe. The critic Achille Delaroche wrote of *"the riches of this tropical vegetation, where an Edenic and free existence idles beneath lucky stars."* The paintings managed to convey this latter-day Eden, the Eden sought by Gauguin since his childhood and absent even at the end of his life.

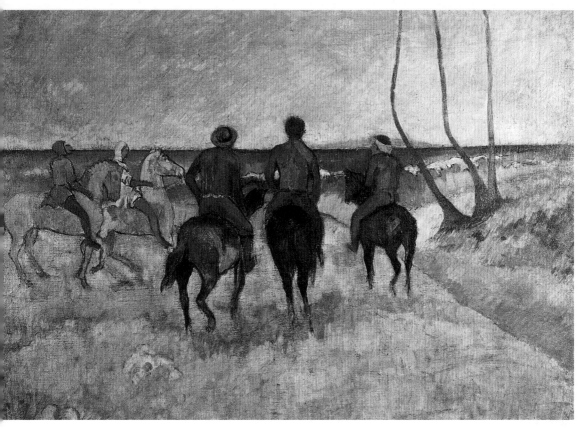

RIDERS ON THE BEACH, 1902

The influence on this late painting by Gauguin of bareback riders on the beach has been clearly identified by art historians as Degas's work *Racehorses at Longchamps*, painted 27 years earlier. Gauguin was quite open about his debt to other artists and especially to Degas for whom he had tremendous admiration. The art historians and critics were slow to accept Gauguin into the world of Western art. The French art historian André Michel wrote a history of the acceptance of Gauguin's work that itself reveals how difficult it was for the art establishment to embrace wayward artists (Michel described van Gogh as "foreign and crazy"). Gradually Michel and others came to appreciate and then to applaud Gauguin's work and to recognize his influence on others.

RACEHORSES AT LONGCHAMPS (*detail*)

Edgar Degas

Gauguin's painting appears clumsy by comparison to Degas's masterly draftsmanship, but Gauguin's work is both magical and sinister as the riders recede toward the horizon over a beach of pink sand. The composition would have been carefully constructed, as revealed in this extract from Gauguin's writings about another Degas picture; *"Before me is a photograph of a painting by Degas. The lines on the floor lead to a point on the horizon, very far, very high, intersected by dancers What is the symbol? Is it eternal love . . . nothing like it . . . it is choreography."*

A LASTING IMPRESSION

*B*y 1899 Gauguin's work was beginning to attract collectors. The dealer Ambroise Vollard struck an exclusive deal with Gauguin that was worth 250 francs per painting and payments of 350 francs per month to secure Gauguin's agreed output of 25 paintings per year. The income kept Gauguin going in his final years although he occasionally needed to supplement this income from menial jobs he could get on the island. Gauguin died on May 8, 1903 at the age of 54. His work had begun to attract interest, which accelerated after his death, although acceptance as a great artist came much later. Artists such as Odilon Redon and Henri Rousseau were aware of Gauguin's images of lush vegetation when they painted their own visions of the tropics and the jungle. Gauguin's Synthetism, which accentuated color as a means of expressing ideas, became very important to the painters who followed, such as Pierre Bonnard and Maurice Denis. Great artists such as Matisse and Picasso who were to dominate the early 20th century owed a debt to Gauguin's freedom with color. Later still Gauguin's languid, dreamlike Polynesian landscapes became an often-quoted visual example of escape from the realities of life in the Western world.

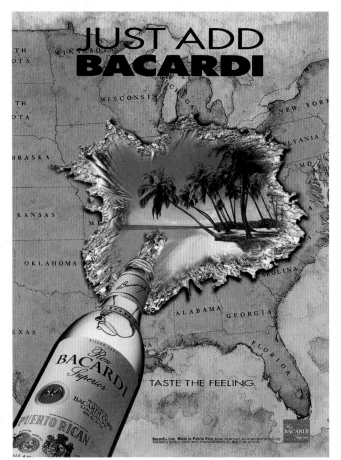

SELLING AN IDEAL

Advertisers use the image of the "primitive" in the same way that Gauguin used images of Polynesia. The unspoiled Eden of the South Seas together with the promise of a way of life unrestricted by Western morals is used time and again to sell products.

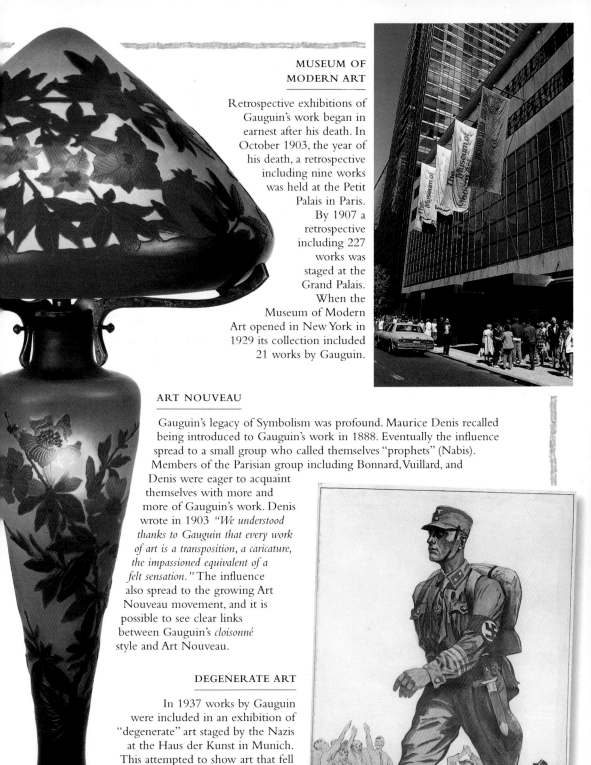

MUSEUM OF MODERN ART

Retrospective exhibitions of Gauguin's work began in earnest after his death. In October 1903, the year of his death, a retrospective including nine works was held at the Petit Palais in Paris. By 1907 a retrospective including 227 works was staged at the Grand Palais. When the Museum of Modern Art opened in New York in 1929 its collection included 21 works by Gauguin.

ART NOUVEAU

Gauguin's legacy of Symbolism was profound. Maurice Denis recalled being introduced to Gauguin's work in 1888. Eventually the influence spread to a small group who called themselves "prophets" (Nabis). Members of the Parisian group including Bonnard, Vuillard, and Denis were eager to acquaint themselves with more and more of Gauguin's work. Denis wrote in 1903 *"We understood thanks to Gauguin that every work of art is a transposition, a caricature, the impassioned equivalent of a felt sensation."* The influence also spread to the growing Art Nouveau movement, and it is possible to see clear links between Gauguin's *cloisonné* style and Art Nouveau.

DEGENERATE ART

In 1937 works by Gauguin were included in an exhibition of "degenerate" art staged by the Nazis at the Haus der Kunst in Munich. This attempted to show art that fell short of the standards in art expected by the Nazis, who only cared for realistic portrayals of heroic Aryan men and women.

GLOSSARY

Nabis - This was the name given to a group of French artists who followed Gauguin's style of painting in flat colors. The best-known of the group were Pierre Bonnard, Édouard Vuillard, and Maurice Denis. Denis said *"Remember that a picture, before being a horse, a nude . . . is essentially a flat surface covered with colors assembled in a certain order."* The name "Nabis" comes from the Hebrew word "prophet."

Easter Island - An isolated volcanic island situated in the Pacific Ocean, 3,700 kilometers west of Chile. The island is so named because it was discovered by Western explorers on Easter Sunday, 1722, but had been the home of aboriginal culture for hundreds of years. It is notable for its gigantic stone figures that stand on its coastline.

Symbolism - An art movement of the late 19th century that attempted to express abstract ideas through the symbolic use of images. The movement also comprised Symbolist writers such as the poets Stéphane Mallarmé and Arthur Rimbaud.

Synthetism - A type of Symbolism adopted by Gauguin and the Nabis. This work is closely associated with Cloisonnism that separated flat areas of color with heavy black lines. The Synthetists reacted against Impressionism to produce brightly colored imagery that reflected their inner beliefs.

Puvis de Chavannes (1824-98) - A painter of Symbolic images in a fresco style that recalled the great Italian fresco painters, although executed in oil on huge canvases. His works can be found in many official buildings in France, most particularly in the Pantheon in Paris. His work was greatly admired by Gauguin.

Edgar Allan Poe (1809-49) - An American short-story writer famous for such tales as *The Fall of the House of Usher* and *The Murders in the Rue Morgue*. His story *The Raven* attracted considerable attention among artists, being illustrated by Édouard Manet as well as being taken up by other artists such as Gauguin who translated from Poe's literary imagery in his paintings.

ACKNOWLEDGMENTS

We would like to thank Graham Rich and Elizabeth Wiggans for their assistance.

First edition for the United States, its territories and dependencies, Canada and the Philippine Republic, published 1998 by Barron's Educational Series, Inc.

Original Edition Copyright © 1998 by ticktock Publishing, Ltd.
U.S. Edition Copyright © 1998 by Barron's Educational Series, Inc.

All rights reserved. No part of this book may be reproduced in any form, by photostat, microfilm, xerography, or any other means, or incorporated into any information retrieval system, electronic or mechanical, without the written permission of the copyright owner.

All inquiries should be addressed to: Barron's Educational Series, Inc.
250 Wireless Boulevard Hauppauge, New York 11788 http://www.barronseduc.com

Library of Congress Catalog Card No. 98-72920
International Standard Book No. 0-7641-0625-2
Library of Congress Cataloging-in-Publication Data

Picture research by Image Select.

Printed in Hong Kong
9 8 7 6 5 4 3 2 1

Acknowledgments: Picture Credits t=top, b=bottom, c=center, l=left, r=right, OFC=outside front cover, IFC=inside front cover, IBC=inside back cover, OBC=outside back cover.

PICTURE CREDITS

Advertising Archives; 30cl. AKG (London); 4/5ct. Ann Ronan Picture Library; 11cb. Anthony Blake Photo Library/© Rosenfeld, 10bl & OBC. Bridgeman Art Library; 6bl, 6tl, 7t, 20tl, 24br, 31br. Christies Images 30/31c. Colourific!; 10/11(background) & 10c. Fotograph Ole Woldbye; 8t, 22tl. Gauguin Museum; 9tr, 24tl. 26tr. Giraudon; 4bl, 5bl & 5br, 6/7cb & 7br, 8c, 8b, 8/9c & 9bl, 10tl, 12tl & 12b & 12/13c, 13tr & 13br, 14tl & 14bl, 14/15cb, 15tr, 16/17t, 16cr & 16b, 18tl, 18bl, 18/19b, 19tl & 19br & OFC, 20/21t, 20/21b & 20bl & IFC, 20/21c, 22/23b, 24cl & 24/25c & OFC, 25tr & 25bl, 26/27c & 27tr, 28tr & 28/29cb, 29t. Giraudon/Bridgeman Art Library; 2tl, 4tl. Glasgow Museums; 22/23c. Mary Evans Picture Library; 3tr. Metropolitan Museum of Art, Bequest of Sam A. Lewisohn 1951, photograph © 1993; 17bl & 17r & OBC. Museum of Fine Arts, Boston; 29br. National Gallery of Washington; 2cl & 2/3c & 32ct. National Maritime Museum (London); 3br. Réunion des Musées Nationaux© RMN; 23r. Superstock; 31tr. Telegraph Colour Library; 11tr.

Every effort has been made to trace the copyright holders and we apologize in advance for any unintentional omissions. We would be pleased to insert the appropriate acknowledgment in any subsequent edition of this publication.

BARRON'S

INDEX

Gauguin

*H*ow different was the world in Gauguin's day?

• Discover how society and the art of the time influenced his work.

• Learn what the pictures tell us about Gauguin and about the methods he used.

• Read about his family and friends, and what people said about his art when he was alive.

A fascinating insight into the life and art of Gauguin.

ISBN 0-7641-0625-2

EAN

9 780764 106255

50595>

$5.95 Canada $7.50

BARRON'S